DSLR Manual Photography Explained! - How to Use Manual Mode...

Getting To Know Manual Mode

Manual is the mode on DSLR camera's which allows you to take control of each variable of your camera's exposure. Thus allowing you to sculpt your images however you prefer. Here are the four variables:

- Shutter Speed - How long the shutter of your camera will stay open. The longer it stays open the more light is let in, and therefore the brighter the picture will be.

- White Balance - How cool or warm the colors of your image will be. The higher the white balance, the warmer toned the image. The lower the white balance, the cooler toned the image will be.

- ISO - How sensitive your camera is to light. - The higher the ISO, the more sensitive your camera will be, and thus the brighter the resulting image will be.

- Aperture (or F-Stop Number) - How large the opening of the aperture is which allows light into the camera. - This one is confusing, but is also one of the most valuable variables which you can control, so I will explain what it does, and how to use it best in the aperture section of this book.

Without further ado let's dive right into understanding and applying these settings and variables in our photography. We'll conquer them in the order presented above.

P.S. The final chapter explains how to use all of these settings to work together to properly expose your photography.

Shutter Speed

What it is: How long the shutter of your camera will stay open. That is, how many fractions of a second your camera allows light to reach it's sensors. For example if your shutter speed is set to 1/60 this means that your shutter will stay open for one sixtieth (60th) of a second, letting 1/60th of a second worth of light in.

What effect it has: The faster (smaller number) you have your shutter speed set to, the less light it will let into your camera, which will give you a darker image. In the same way the slower (larger number) your shutter speed is, the more light will be let in, and the brighter your image will be.

Too Fast Shutter Speed (Causing the image to be underexposed):

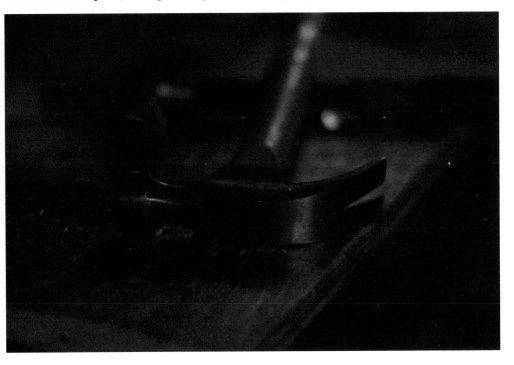

Properly Set Shutter Speed (Creating a beautifully exposed image):

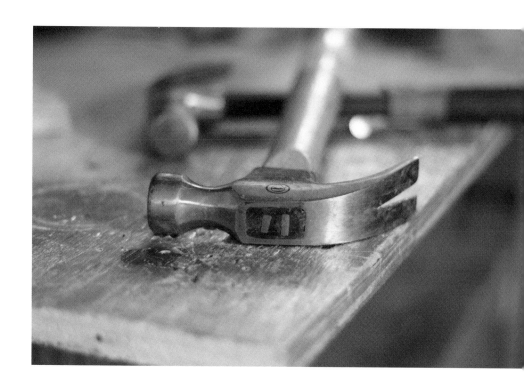

Too Long of a Shutter Speed (Causing the image to be overexposed):

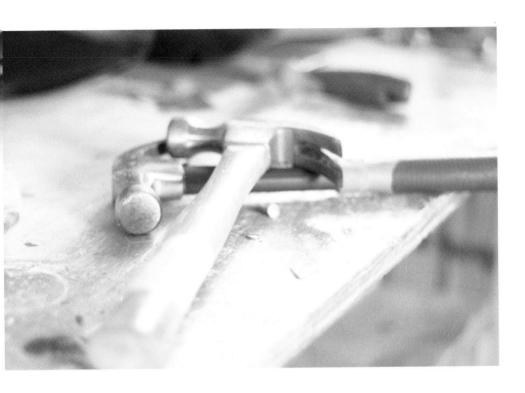

Lower shutter speeds will also result in more of a chance of your picture or parts of the picture becoming blurred. This is because if your camera is allowed to take in light for too long an amount of time, there is a good chance that either what you are taking a picture of will move slightly, or you holding the camera will move slightly. This results in a shaky image like below.

Higher shutter speeds generally take care of this problem, as there is less time in which anything has the chance to shake or move in your image.

What you should set it to: When choosing a shutter speed to use you must always keep in mind that it must be balanced with the two other variables that affect how bright your image will be, that is the aperture and the ISO. But we'll talk about how to balance these variables in the final chapter. For now however it is enough to realize that what you set it to is determined by both what you are shooting (how well lit it is, and how much it is moving), and what your shooting style is.
If you are going for a dramatic dark look, set the shutter speed somewhat faster, if you are going for the opposite, set it somewhat slower.

Below are some general guidelines on what you should set your shutter speed to in various situations.

How to use it effectively:

Using and setting your shutter speed effectively and to your advantage can pretty much be summed up in the word balance. That is, you must balance between setting your shutter speed too fast, and ending up with a photo that is much too dark, or setting it too slow, and ending up with an image that has undesirable motion blur.

It also depends in large part upon what it is that you are shooting, and also how well lit what you are

shooting is.

- Mostly still subjects. Such as people/animals standing still, or other situation where your subject is mostly, but not perfectly still.

 For situations like these you should keep in mind that your subject is always moving, if only slightly. After all, they cannot stop breathing, nor can they stand/sit still as a rock without swaying! Because of this you should try to have a relatively fast shutter speed, preferably above 1/100 of a second. This will help the camera not capture any of the blur caused by you or your subject's slight movements.

 But how slow of a shutter speed is too slow? A good rule of thumb is to never go lower than 1/40th of a second in situations like these. There is simply too much of a probability of ending up with a blurred photo if you go slower than this.
 But also keep in mind that how slow a shutter speed you can go to depends also on how still you are able to hold the camera, it is a learned art, but the better you get at keeping your camera stable, the less blur you will have, and the lower you can set your shutter speed.

- Moving Subjects. Such as sports, running kids, or a busy street.

 Here you will want as fast of a shutter speed as possible. The idea here is to freeze the motion of what you are shooting, this of course will require an extremely fast shutter speed, the faster your subject is moving, the faster your shutter speed will need to be.
 The inhibiting factor here will be how well lit what you are shooting is, if your subject is well lit, then you should be able to have a much higher shutter speed than if it is poorly lit. After all, you must keep in mind that the higher your shutter speed is, the less light that will be let into the camera.

 How slow of a shutter speed is too slow? Again, this is an impossible question to answer, but the "correct" answer here is that you should never have your shutter speed so slow that it causes undesirable motion blur. Having a shutter speed above 1/1000 is a good place to be, but of course, bad lighting often times does not allow for this.

- Perfectly still subjects, shot from a tripod. Such as landscapes, food, architecture, etc.

 Here we have an ideal situation for using the shutter speed to our advantage. Here's why; there is practically no chance of having any undesirable motion blur. This means that we can set the shutter speed to whatever we would like, without having to worry over the chance of motion blur happening.

 In situations like this simply set the shutter speed so that it gives you whatever mood you would

like. If you want dark and moody have a faster shutter speed, if you want bright and happy, have a slower shutter speed.

Because of this complete creative control we have shooting a still subject from a tripod there are many interesting and breathtaking possibilities of creative shots opened to us, that are practically not possible otherwise. Here are a few:

Flowing Water - Have you ever seen pictures of a flowing stream that looked almost like glass, where the waters looked strangely - yet beautifully - smooth? Well, chances are that the photographer who took this picture used a tripod and took advantage of their shutter speed by shooting with a fairly long exposure.

To achieve this effect you must be either using a tripod, or setting your camera upon a stable surface. Once you have done this set your camera's shutter speed to a number higher than 1' (one second) and take the picture. The result should be that the stream looks as if it is now made of glass.

This is because the shutter was left open for such a long amount of time the resulting image is not that of a stream frozen in time, but rather that of a stream over a long period of time. The parts of the stream that are most consistent in where they flow will end up being the main remaining part of the stream in the picture, forming a smooth glassy effect.

Lightning - Most of the time lightning can be very hard to capture on camera without special equipment because it happens so randomly and is over so quickly that most people's effort to capture it is in vain.

However if we use a long exposure setting on our camera then our chances of capturing the lightning increase greatly. The longer we leave our shutter open, the more chance there is of lightning striking, and the more chance we have of catching that lightning. The brilliant thing here is that the very lightning will act as the lighting for your scene, so you do not have to worry about how slow of a shutter speed you have making the scene too dark.

To capture lightning, set your camera up on a tripod towards where the lightning has been concentrated, and set your shutter speed to an extremely slow setting. Keep taking pictures until you capture one with lightning.

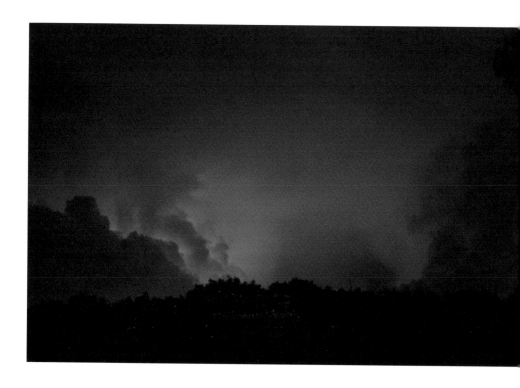

Dawn/Dusk - In early dawn or late dusk it is often times too dark to take photographs, however as above if we simply set our cameras on a tripod and use a long exposure shot, than we will be able to capture enough light to have a beautifully exposed picture.

How slow of a shutter speed you have depends upon how dark it is, simply use a slower shutter speed the darker it is. After some little experimenting you should be able to figure it out.

White Balance

What it is: How cool or warm the colors of your image will be. In other words the tones of your picture are either going to lean towards reddish/orangish (warm) tones or they are going to lean towards bluish (cool) tones. The white balance determines relatively how warm/cool the colors of your picture will be.

What effect it has: The higher the number the white balance is set to, the warmer toned your picture will be. The lower the number, the cooler toned the picture will be.

Too Low of a White Balance Setting (Resulting in a very bluish image):

In the Middle White Balance Setting (Resulting in an image approximately how the human eye would view the scene):

High White Balance Setting (Resulting in a slightly warm toned image):

What you should set it to: The white balance is unique among the variables you can change in manual mode, because the white balance is independent from the rest, and therefore you can set it to whatever you would like without having to balance it with any of the other settings.

There are at least two philosophies with setting the white balance. The first states that you should always leave your white balance (WB) on automatic - which is an option within manual mode - simply because auto is normally very accurate, and therefore why would you fix something that is not broken? The other philosophy is that you should manually choose your white balance so that it complements your style, and that if you let the camera automatically choose it for you, than you will lose this creative control.

Both are fine philosophies, and are used by many extremely successful photographers who are acclaimed as masters. However for the sake of discussion we will adopt the second philosophy.

How to use it effectively: When setting your white balance it is helpful to realize that it should be adjusted based on your surroundings and what you are shooting. This is because everywhere you go has a different natural color temperature, for example if you are taking a picture of something indoors under incandescent lighting than that area will naturally be extremely warm toned, simply because of the warm yellow light of the bulb. However if you were to take a picture of something outside and in the shade at the same WB setting as you did indoors then your picture would likely be very cool toned, because of it's unique lighting situation.

Therefore you can not simply set your WB to one setting, and then just leave it at that for the entire time you are shooting, instead you must constantly be adjusting your WB based on your changing surroundings.

In areas that are naturally warmed toned you should adjust your WB to a lower (cooler) setting, and vice versa.

Be on the lookout for places/areas that naturally tend to have warm or cool colors, and should be compensated for. For example some areas with naturally cool tones are: Cloudy days. Outdoor shade. Indoors lit only by a window. Sometimes even outdoors on a cloudless day, especially in early morning o late afternoon.

Areas that tend to have warm warm tones: Indoors under artificial light. Outdoors at noon.

Aside from compensating for areas that are naturally warm/cool toned, you may also use custom WB settings to complement your own photography style. For example you might prefer a warm happy tone to your photography, so in this case you should always have the WB set intentionally somewhat high. Or vice versa.

Here are some ways you can use WB to add the icing on the cake to your photography.

- Set your WB on the high end when shooting sunsets or sunrises to give them the extra "wow" factor, and to add a rich warm tone to the sunset/rise, bringing out the color of the sun.

- When shooting people turn your white balance higher to give their skin a nice warm glow, this is especially helpful on people who do not have much of a tan, as it can help keep their skin from looking pale and bluish/yellow.

- Use a cooler WB setting when shooting snow to add to the sense of cold. Also keep in mind that if you have a warm WB here than the snow might look yellow, which can either be a good or a bad thing, depending on what you are going for.

ISO

What it is: The ISO essentially determines how sensitive your camera's sensors will be to light. The higher the ISO, the more sensitive they will be to light.

What effect it has: The ISO has two main effects: The first is that the higher your ISO is, the brighter your photos will be, and vice versa. The next, is that a grainy texture will develop in your pictures if you turn your ISO up too high. This is the natural consequence of making your camera's sensors extremely sensitive to light.

Close up of a picture with high ISO (Causing "grain" on the image):

Now with a medium to low ISO, causing much less grain:

What should you set it to: The rule of thumb with ISO is to always set it as low as possible (normally 100), except as a last resort to brighten pictures that are too dark. The reason we want to avoid using the ISO as a ordinary means of increasing our exposure is because of the risk of grain.
However when we are out of other options turning up the ISO can be a wonderful tool to use when your pictures are turning out too dark.

Another rule of thumb is that you should always avoid using any ISO above 800, in fact, to pretend that it does not exist on your camera. If you go above 800 the grain will become extremely noticeable. Generally ISO's of 100-400 will have acceptably low amounts of grain, and are fine to use.

How to use it effectively: There are at least two ways to use ISO, the first is to intentionally always use a low ISO, so as to avoid grain ending up on your picture.
However another way that the ISO can be used is to intentionally turn it up very high, so as to intentionally end up with a very grainy picture to give it a rough unpolished feel, this can work very well with black and white pictures. If you are intentionally going for this effect than turn your ISO up above 800.

However the main purpose of the ISO is to be used as a tool to help you properly expose your image along with your shutter speed and aperture. To this end you should use the ISO in dark lighting situations to help properly expose the picture, but remember this should be used after you have already adjusted the shutter speed for the lighting situation.

Aperture (or F-Stop Number)

What is it: I have tried so far to keep my distance from getting too technical in my explanation of many camera settings. So I will try to keep it that way, but essentially the aperture determines how large the opening of the aperture is which allows light into the camera. (This does not change how large your picture is.)

Before we move on let's clear up some terminology confusion that normally besets DSLR newbies:

Both aperture and f-stop refer to the same thing, however they are referred to somewhat differently. When referring to it as an F-stop, the higher the number indicates a smaller aperture, and likewise when talking about apertures a smaller aperture means a larger F-stop number. Of course, vice versa is true as well.

Larger F-stop number = Smaller Aperture

Larger Aperture = Smaller F-stop number

What effect it has: The aperture has two main effects on your photography. The first is that the wider the aperture (smaller number) the more light will be let in, and brighter your photograph will be. The second and possibly more important effect it has is that it determines the depth of field (DOF) of your photograph.

The DOF is the distance between the nearest and farthest objects in a scene that appear acceptably sharp in an image.

In other words if you took a picture of a penny where the penny was in focus, and everything else, background and foreground were blurry, then the penny would be the only thing inside of the DOF. This is a very shallow DOF, as it is only a few inches large.

However if you took a picture of a vehicle, where the vehicle was in focus, but the background was blurry and out of focus, than the vehicle would be what is inside the DOF. This is a moderately large DOF, as it extends quite a few feet.

Of course if you took a picture where everything was perfectly in focus then this would be an extremely

large DOF.

Anyway, the wider the aperture (smaller number) the shallower the depth of field will be. In the same way the smaller the aperture (larger number) the larger the depth of field will be, and more objects that will be in focus. For example in an extremely wide aperture of f1.8 only a few inches will be in focus, everything else will be blurry. Or in a extremely small aperture of f22 almost all of the scene should be completely in focus.

Aperture set to a very wide setting (small number), creating a very shallow depth of field:

Aperture set to a medium small setting (high number) making much more of the image be in focus:

What you should set it to: Our first concern should be to light our image correctly and beautifully. The aperture should therefore be adjusted as needed either up or down to help properly expose the image. That being said however, I would personally use the other variables such as shutter speed and ISO to ensure that your photograph is properly lit, and if possible I would only use the aperture to control the DOF.

In general it is a good idea to leave the aperture set to as low of a number as possible, this will allow the most light into your image, and also create a shallow DOF. The only time you should turn the number up is when you want or need a larger DOF, such as when you are taking landscape photographs.

How to use it effectively: This is where your individual style comes into play. Normally photographers tend to fall in one of two camps. The first are those who prefer everything in their image to be perfectly in focus with no blur whatsoever. If this is you than a small aperture (large number) is more appropriate for your style, start out at f/4 and move up from there.

The other camp are the photographers who love the buttery smooth background that a shallow DOF gives, and want their subject to be one of the only (if not the only) things in focus. This way the eye is drawn to

the subject, not elsewhere. If this is you then you should pretty much always have your aperture set as wide (small number) as your lens will allow. Which also has the advantage of letting in the most light.

This being said however different types of photography work best with different aperture settings:

Landscape Photography: Should almost always be shot at a very small aperture (large number). So as to have every part of the landscape in focus.

Architecture Photography: Should be shot with a small aperture (large number) to keep the entire photo in focus.

People Photography: Either style will work, each has it's advantages and disadvantages.

Animal Photography: Same as People Photography.

Details and Still Life Photography: These types of photography focus on the small things in life, and normally a large aperture (small number) giving a shallow depth of field will work best, and will add to the interest of your subject by taking away distractions.

Street Photography: Normally a very small (large number) aperture is best here, as you have the most chance of "getting the shot" if everything is in focus.

Putting it All Together

Now that we understand how each of the components of manual photography work, let's close by talking about how to put it all together.

Here is the process you should go through when setting your settings:

- ISO - This should be the first setting you adjust when starting to shoot. Start off by turning it to the lowest setting possible, normally 100. Now leave it alone, if we need it to help lend a little light to the picture later we'll adjust it then. For now however we want to keep it as low as possible.
 Take a picture, and check to see how properly it is exposed.

- Aperture - Next you should adjust your aperture so as to give whatever effect you want in terms of Depth of Field. Keep in mind that if you set it on either a high or low extreme you will also be drastically changing amount of light let into your camera.
 Take a picture, and check to see how properly it is exposed, and whether it meets your desired DOF.

- Shutter Speed - Next set the shutter speed to a setting high enough that you are not likely to have any trouble with motion blur.
 Take a picture, and check to see how properly it is exposed.

- Now it get's interesting, now that you have each setting set to their individual ideal settings we must now adjust them so as to be able to take properly exposed pictures. In all likelihood the picture you just took is either far too bright, or far too dark, now we should fix this.

- *If the picture is too dark (underexposed) than do this:* First turn your shutter speed a few clicks slower, then take a picture and see if the problem is fixed. If it is still too dark then repeat this, turn the shutter speed a few clicks slower, and take a picture to see if the problem is fixed. Do this until your image is properly exposed.

 However, if you keep lowering your shutter speed your pictures will eventually start to become blurred from the motion of your subject and your own motion, normally at around 1/40. If this motion blur happens and your picture is still too dark then turn your shutter speed back up to the last setting that had no motion blur.

Next turn your ISO up one notch, to 200, take a picture and see if it is properly exposed. If not then repeat the process, turning the ISO up by a notch, taking a picture, and so on until it is properly exposed.

Lastly if you get up to a high enough ISO number that it causes too much grain and the picture is still too dark then you must sacrifice your aperture, and in the same way as the two previous settings turn the aperture wider (smaller f-stop numbers) by notches, taking a picture, checking the exposure, adjusting as needed, and so on, until it is properly exposed.

If your image is still too dark after all of this than you quite simply are trying to take a picture of something that is too dark, and you will need use either a flash or other light sources to make your subject bright enough for this picture to be possible.

- *If the picture is too bright (overexposed) than do this:* Quite simply just turn up your shutter speed by small increments until the image is properly exposed, always taking test pictures to check how close you are to being correct. Make sure your ISO is as low as possible.

- White Balance - Set it to whatever you would like to fit your personal photography style. It does not affect the brightness of the picture.

Now I know! This all can seem very overwhelming, it seems like a long and never ending task to end up with a properly exposed picture. This is true, at the start it will be. But after a few weeks of daily practice this process will start to become second nature to you, and you will start to be able to do it in seconds, rather than in minutes.

Bonus Book:

Photography Composition Revealed…

How Composition Can Make Your Photography
Become Breathtaking...

Using Light To Draw The Eye

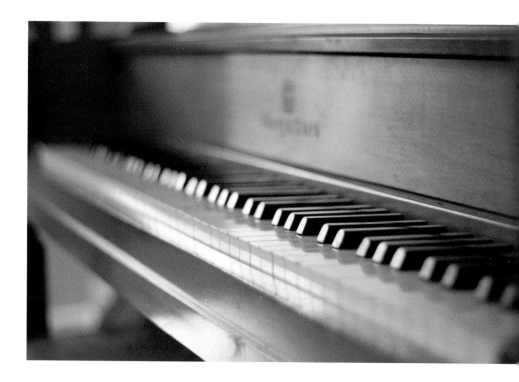

When composing your photography you should actively have in mind what is important, and what you want to draw your viewers eyes towards. This is key, because if you do not use your composition to highlight and accentuate what is important in your photograph, then they will quickly lose interest in it.

Light draws the eye, and for the most part the brighter the light, the more it will draw the eye, and the less bright, the less it will draw the eye.

We can use this to our advantage. By strategically making sure that the subject of our image is brighter than the background we will subtly draw the eye away from the background and to our subject.

For example look at the above photo of the piano. Notice how the keys closer to us and closer to the bottom right corner are fairly bright, and the keys that are farther away slowly become darker? Well this is extremely important, because the subject of the photograph is not all of the keys on the piano, rather it is the handful of keys that are both in focus, and slightly brighter than all of the other keys. Both of these elements coupled together make for an very strongly composed photograph.

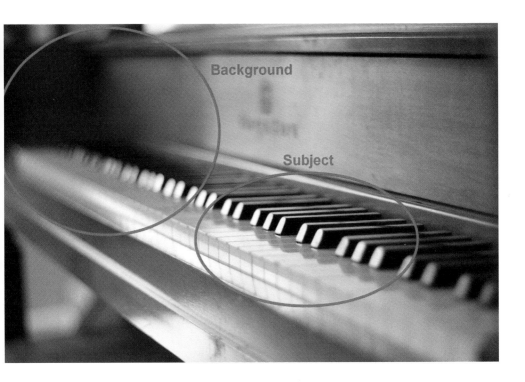

Now let's look at another picture of the same piano, except with approximately even lighting:

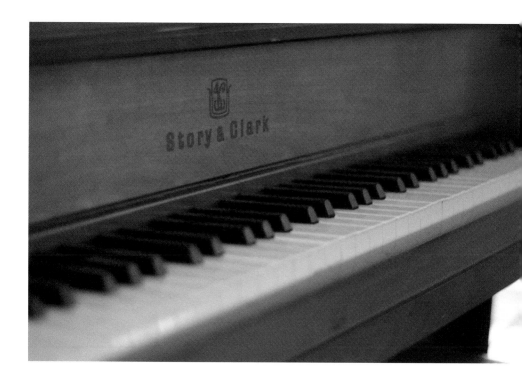

In most respects this picture is the same as the first, it is the same piano, a similar angle and shot a few seconds after the first picture.

Except this picture was taken from the opposing angle so it did not take advantage of the beautiful window light. The result as you can see is that it is lit with a fairly even and bland lighting throughout the picture. This results in the viewer not knowing what is important, and not knowing where to rest their eyes, in the end this makes the picture become bland.

All in all it is a pretty boring and average picture, comparatively to the first.

Light Your Background Darker Than Your Subject, and subsequently: **Light Your Subject Brighter Than Your Background.**

Use Light To Draw The Viewers Eye To Your Subject.

Depth Of Field

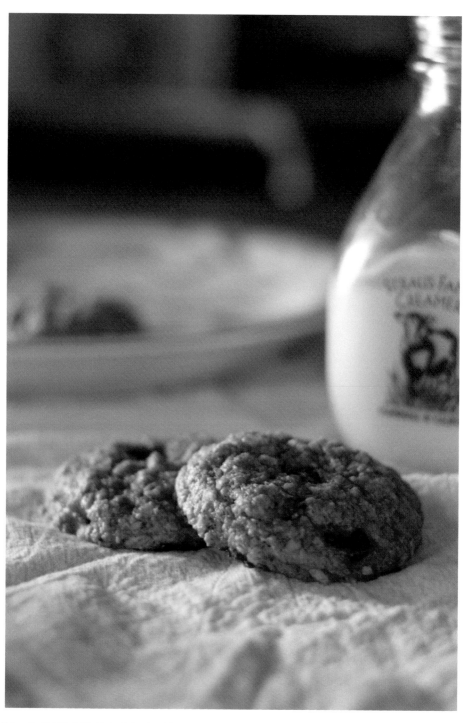

The "Depth Of Field" (DOF) is the distance between the nearest and farthest objects in a scene

that appear acceptably sharp in an image.

For example in the above photograph the plate and the milk jar in the background are outside of the depth of field, and therefore blurry, and part of the cloth at the very bottom of the picture is also out of the DOF and therefore blurry as well.

However for the most part the cookies *are* inside of the depth of field, and thus they are in focus.

In the last rule we talked about using lighting to attract the viewers eye to the subject of your photograph. Well you can also use your camera's depth of field (or aperture) to direct the viewers eye to your subject as well. Essentially these are tools that subtly point out to the viewer how interesting your subject actually is, and let's them know that everything else is not nearly as important.

To attract the viewers eyes to your subject: **Place your subject inside of the DOF (so that your subject is in focus) and place the supporting elements of the photo - background & foreground - outside of the DOF (so that they are blurry).**

As you can see in the above photograph the subject (cookies) is in focus, while everything else is blurry. This clearly tells the viewer that the cookies, and not anything else, is the subject of the photo, which makes for a great photograph with strong composition.

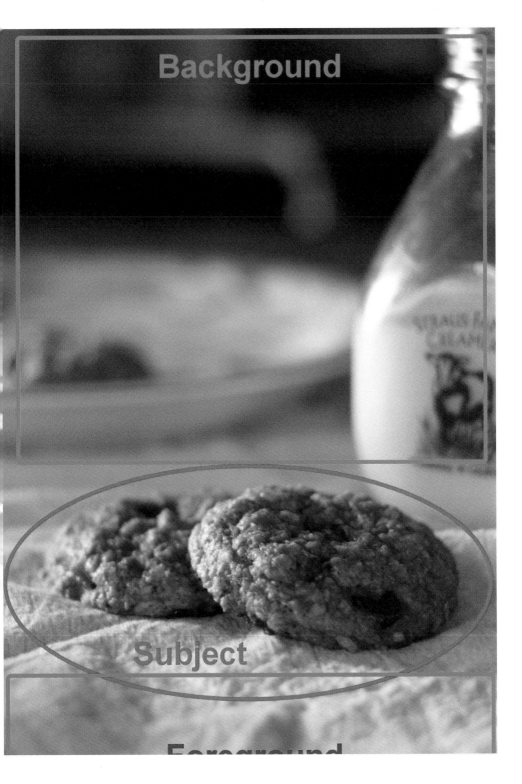

Negative Space

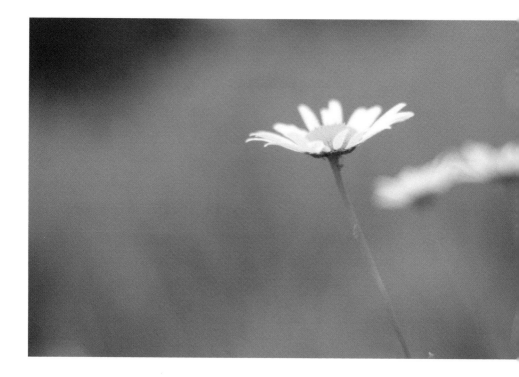

Negative space is the space around the subject of an image that does not distract from the subject. For our purposes negative space refers to things such as a blank sky, a one-color background (such as in a studio or as formed by a painted wall), or as above in a background that is so blurred that it becomes indiscernible.

So, how do we use negative space? As with both previous composition techniques, we use negative space to draw the viewer's eye towards the subject, complement the subject, and give the the viewer's eyes a place to rest in the subject, rather than being distracted by the background.

The idea here is to not distract your viewer with a messy or complex background, but to use the background as something which adds (not detracts) to the subject of the image. If your background attracts their eyes away from the subject, then they will quickly lose interest in your

photograph and move on.

For example, in the above photograph there are two flowers in the background that are just as beautiful, and just as interesting as the flower that is in focus. But what would happen if I changed the aperture so that they were in focus as well? In short they would take the viewer's eyes away from the subject, and confuse them as to what they should be looking at, which of course is not a good idea.

Compose your photograph in such a way that the background is mainly (at least 50%) negative space. This of course is not a technique that should be used in every photo, but when you do use it, it can be very powerful.

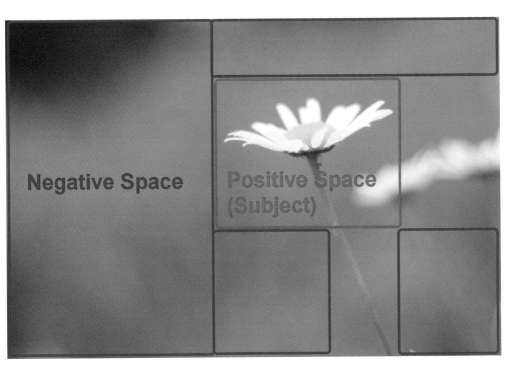

Another powerful use of negative space is when you compose your photograph so that your background is approximately 50% negative space and 50% positive space (i.e. objects that are tangible, and draw the eye. Such as your subject.) this equal balance will give your photograph an aesthetically pleasing balance, with both equal points of interest (your subject) and areas of rest for the eyes (the negative space).

The Effect What Angle You Shoot From Has On Your Photography

Another concept that set's apart the amature from the expert photographer is that of angles. That is, knowing how to shoot from interesting (and often unusual) angles which add to the photographs appeal, and create a dynamic feel within the image, rather than an average and boring feel.

The mistake most every beginner will make is shooting from whatever angle they happen to be standing at when they start shooting. Aside from the fact that this is what everyone else does, it normally is not an angle that is complementary to whatever they happen to be shooting.

So, what types of angles should be used, and when? What's more, what angles should be avoided? Well this really depends on what you are shooting, and what kind of a feeling you would like to evoke in your viewer. For now let's look at three broad categories of angles, even though many others exist (i.e, to the side, behind, etc...)

Our three categories are 1.) Eye Level. 2.) From Above. 3.) From Below.

1.) Eye Level - If your subject is a person or animal than this angle is exactly what the name says, at eye level with the subject. If it is not, such as the flowers in the above picture, than this angle can be thought of as even, or level with the subject, not above or below. For example, the above photo is eye level with the flowers.

This is one of my favorite angles to use. Here's why. When shooting at this angle - especially when used on animals or people - it creates a sense of trust, and connection with them, in the same way that a firm handshake or looking someone directly in the eye does. You are on the same plane of existence as them, and therefore you can relate to them. Your subject becomes more interesting.

For example the above picture is shot at eye level with the flowers. This creates interest immediately simply because of the fact that throughout our entire lives we have become used to looking at flowers from the top down, and this new and unusual way of looking at flowers reveals more of their hidden beauty than we tend to notice in everyday life.
But another reason this angle is more interesting is simply because it is on the same plane as the flowers. Simply put, your are viewing the flowers world from a flowers eye. It is beautiful.

Here's another example of an eye level angle:

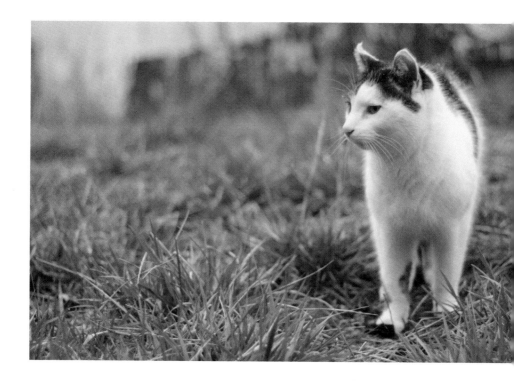

What is happening in the above picture? Essentially the same thing is happening as in the flower picture. Normally we would look down on a cat from above, but now we are looking at one from eye level, this both grants us a glimpse of a new and interesting way of looking at a cat, and also allows us to see life from their perspective.

But looking at a living person or animal from this angle also does something else. It allows us to look them in the eye without looking down on them, or looking up to them. It creates a sense of equality with them.

For example in this picture one might find themselves wondering what the cat is looking at in the distance? When if this picture was shot from above the thought would never enter our minds. We also might wonder whether the day is cold or hot, dry or wet, and so on, simply because we now are looking into the cat's eyes at eye level, and wondering what he is thinking.

What subjects does an eye level angle work well with?
Anything that we normally tend to look down on. For example children, animals, food, flowers and so on.

Also use this angle whenever you are shooting people who you would like to create a strong sense of connection with.

2.) From Above - Essentially any angle noticeably higher than eye level.

This angle can be risky to use, but it also can pay off fairly well. Here's why it can be risky: Just as the eye level angle could be thought of as looking your subject in the eye, and thus creating a sense of trust, this angle could create a sense of "looking down upon" your subject, and thus subconsciously making them inferior to you.

Another risk with this angle is that many times when we take a picture from above the object we are taking a picture from the same angle that we normally see that object from in everyday life. Because we see this object normally from this vantage point, a photograph shot from this same angle can be just plain boring.

For example if we view the same flowers we have been looking at from too high of an angle, they simply become flat and boring. Average if you will.

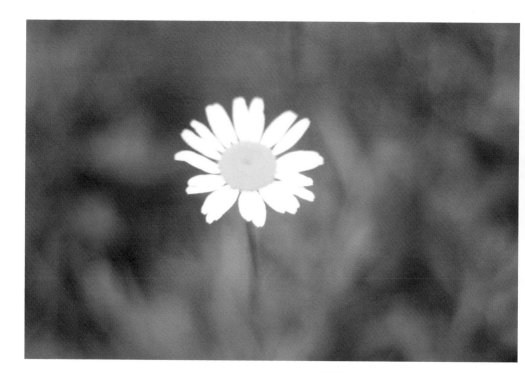

That being said this angle can be used to great effect as well. One of the most valuable ways you can use this angle is by using it on objects that we normally look up to, which of course allows us to view them from a whole new perspective. For example if you were wanting to shoot an old wooden doorway, than one good angle could be from above, simply because we are used to doors being taller than us.

Another good way to use this angle is to use the extreme of shooting almost directly above your subject, this can give the impression of almost having a birds eye view, and looking down on your subject from the sky, which can be both interesting and appealing.

The main thing to keep in mind is that of how great of an angle you are shooting from. A very high angle will affect your photo in a completely different way than an only slightly high angle will.

3.) From Below - Essentially any angle noticeably lower than eye level.

Generally when shooting people this is an angle that you will want to stay away from, simply because it tends to be an unflattering angle. It will also tend to make people look heavier set than they actually are.

However, when shooting children it can be used sometimes to reverse the roles of adult/children, and make the viewer "look up" to the child.

As you may have guessed, shooting from this angle will also have the effect of making the viewer feels as if they are "looking up to" whatever your subject is. Which depending on how you use it can be helpful, or not.

A peculiarity of this angle is that it tends to make everything appear larger than it actually is.

When you are shooting things such as architecture, landscapes, nature, inanimate objects, food, and so on, this can be a great angle to shoot from! Because of it's effect of magnifying how large objects appear it can be used to make a rather larger rock look even more impressive, it can make a building seem breathtaking, and so on.

Also use this angle whenever you are wanting something just totally *different*. Because this angle is so rarely used it tends to catch peoples eyes when they see a picture shot from this angle, therefore, don't use it too often lest it becomes old and stale, but when you are wanting a completely different and interesting angle, try it out!

The Rule Of Thirds

The rule of thirds is thought of by many professional photographers as the most important rule of all composition, and for good reason: By implementing this relatively simple rule your photography can easily jump many leagues ahead in quality!

Essentially the rule of thirds is this: If you take a photo and place two imaginary horizontal lines across it, dividing the photo into three horizontal rectangles, and if you take two vertical lines and do the same then you will end up with an imaginary set of lines like those below:

Now that you have your imaginary lines the rule is this: **You should place the most important parts of your photograph, especially your subject on these imaginary lines.**

As you can see the photo is divided into three vertical sections, and three horizontal sections, which of course is where the name comes from.

The human eye will naturally be drawn to look at objects along these lines, it naturally consider's things that are placed along them as important! However the natural tendency for beginners is to place what they are shooting smack dab in the middle of their frame, not realizing that this many times will detract from their photography.

If you want to add even more interest to your subject, then place it where two of the imaginary lines intersect!

Now, let's look at some examples of the rule of thirds in action:

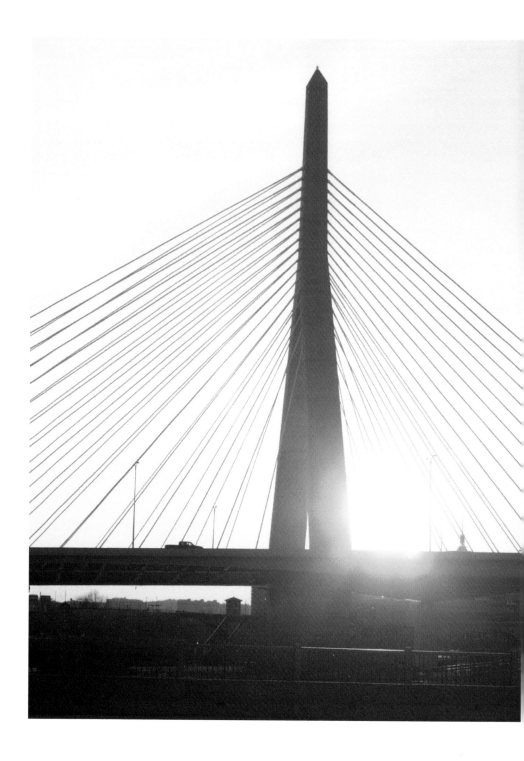

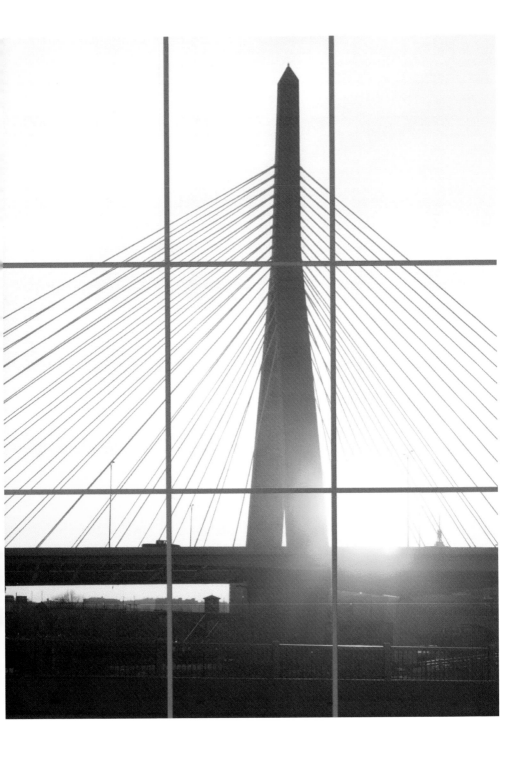

Above is a picture of a bridge in Boston at sunset. There are two points of interest in it, the bridge, and the sun itself. Now I want you to notice something about it:

Notice how the picture is composed so that the sun is approximately where two of our imaginary "rule of thirds" lines intersect? The fact that the sun is where two lines intersect in itself adds a double dose of interest to the sun.

Also take notice how the tower of the bridge is placed just to the side of one of our "rule of thirds" lines, and the bridge itself is just below another? Even though they are not placed exactly on top of our imaginary lines, it still does the trick.

Here's another:

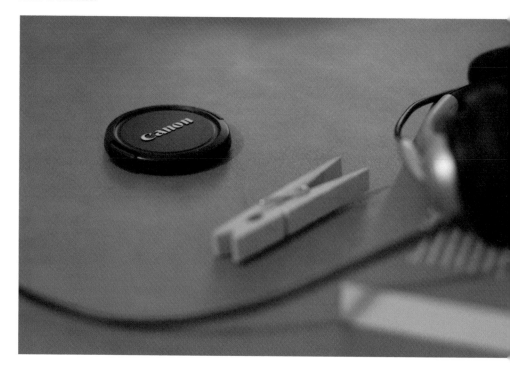

What strikes you as the subject of this photograph? The Clothespin? The Book? No. It is obvious, the Canon lens cap. Why? Well, in large part because the photograph is composed so that the lens cap is where the left vertical and top horizontal lines intersect. Nothing else in the photo explicitly is placed so they it takes advantage of the rule of thirds.

So now the question you must ask yourself is what is the focus of, or the most important part of

your photograph? If you are photographing people or animals then the answer is probably their eyes. So place their eyes along one of the lines, or better yet, place their eyes where two lines intersect.

Or for example, if you are photographing food then the most important piece of food should be composed to take advantage of this rule, and so on.

You get the idea: **Place elements of your photo that you want to add extra interest to along the rule of thirds lines. If possible place it where two lines intersect.**

Leading Lines

One of the main skills that separates the professional and the expert photographer is his ability to direct the viewers attention and eyes wherever he wants. One of the main way's he does this is through composition, and one of the best concepts in composition to do this with is the the concept of leading lines.

Leading lines are lines formed in the photograph which "lead" the eye along and into the photograph. Our goal should be to use leading lines to draw the viewer's eye into and to our subject. Now this might seem a little hypothetical, so let's look at some pictures to demonstrate this:

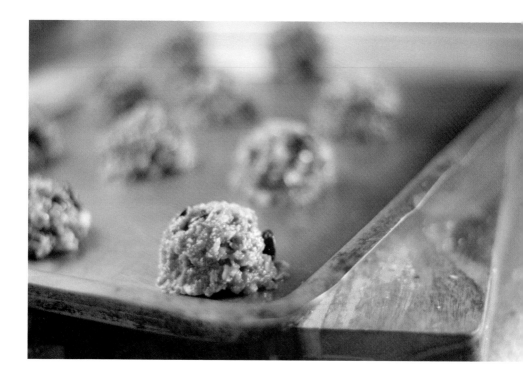

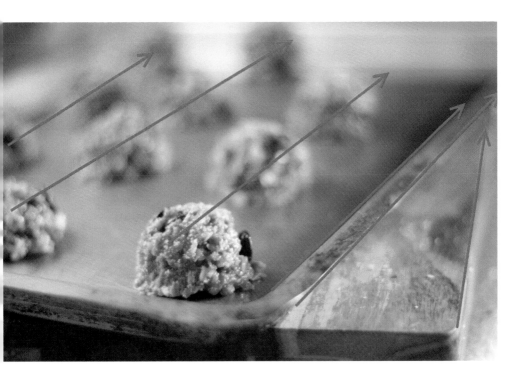

As you can see there are two types of lines: Actual lines, and implied lines. For example there are two actual (i.e. what you normally think of as a line) lines formed by the edge of the cookie sheet, and one actual/real line formed by the edge of the cutting board.

But also look at the cookies, notice how they are "lined" up in rows so that if you look at them from the proper angle - as we are above - each row forms an implied line

All of these lines act together to pull your eyes into the picture, and to make it much more interesting. This, coupled with a few other compositional techniques (rule of thirds, DOF, etc...) also helps to draw the eye into the main subject of the photograph, the cookie that is in focus.

The natural question to ask now would be this "If the lines are leading your eye into the photograph, wouldn't that draw them away from the subject (cookie)?" The short answer is no, because as the leading lines are drawing your eyes into the photograph, the subject (cookie) grabs your attention. The leading lines are still drawing your eyes into the photograph, but as they draw your eyes into the photograph, they also are drawing your eyes into the subject (cookie).

In this picture the four strings of the violin act as leading lines and draw our eyes along the violin and into the picture. But if you look even closer at the picture you will notice two more leading lines. The bow, and the bow hair are also acting as leading lines drawing the eye into the picture as well.

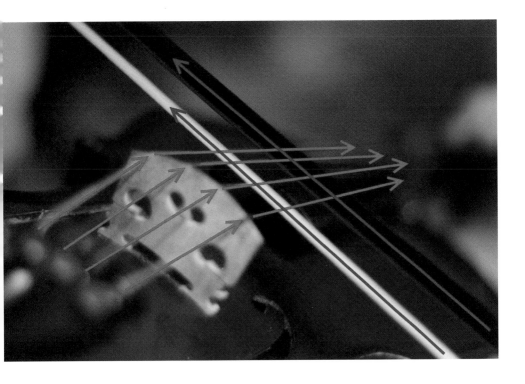

This combination of leading lines starting at each bottom corner and leading up into the picture can be extremely effective.

Generally your leading lines should start at the bottom corner(s) of the picture, and lead up into the picture. Instead of starting in the middle or at the top and heading downwards.

You can use anything you would like to form a leading line, whether it is a park bench, the lines formed by a brick wall, and so on. You can even use lines that are not completely straight! For example a curved road can be used effectively to draw the eye into a photograph, thus making it more interesting.

Use leading lines to draw the viewers eyes into your photograph, and to your subject.

CPSIA information can be obtained
at www.ICGtesting.com
Printed in the USA
LVIC04n2315261014
410574LV00022B/265

* 9 7 8 1 4 9 6 1 0 6 4 4 5 *